DRAWING HORSES

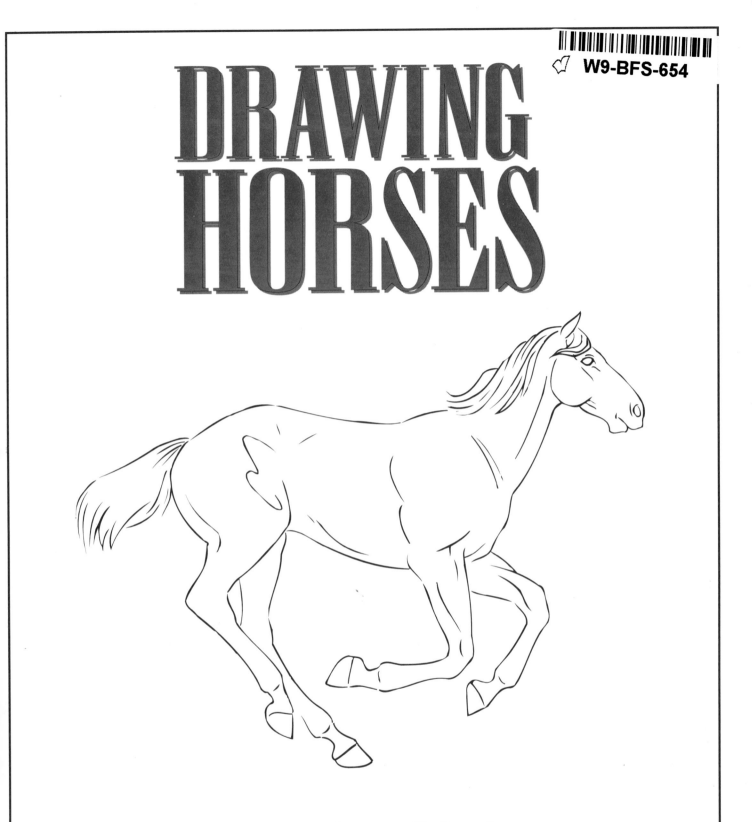

Illustrated by Jeff Crosby

ISBN 0-448-41969-6 A B C D E F G H I J

Have fun drawing horses!

HELPFUL HINTS

∪ Work slowly, one step at a time.

∪ Use a sharp pencil with an eraser.

∪ Look carefully at the instructional drawing to see:
 the sizes of the shapes in relation to each other,
 the lengths of the lines,
 the sizes of the curves,
 the sizes of the angles, and
 where lines cross other lines.

∪ Draw lightly at first. This is called sketching.

∪ For a finished look, darken the important lines
 and erase the lines that are unimportant, such as
 the circles and rectangles.

∪ Remember, the more you draw, the better you get,
 so draw a lot!

∪ Just as your handwriting is unique, so is your drawing style.

PROFILE

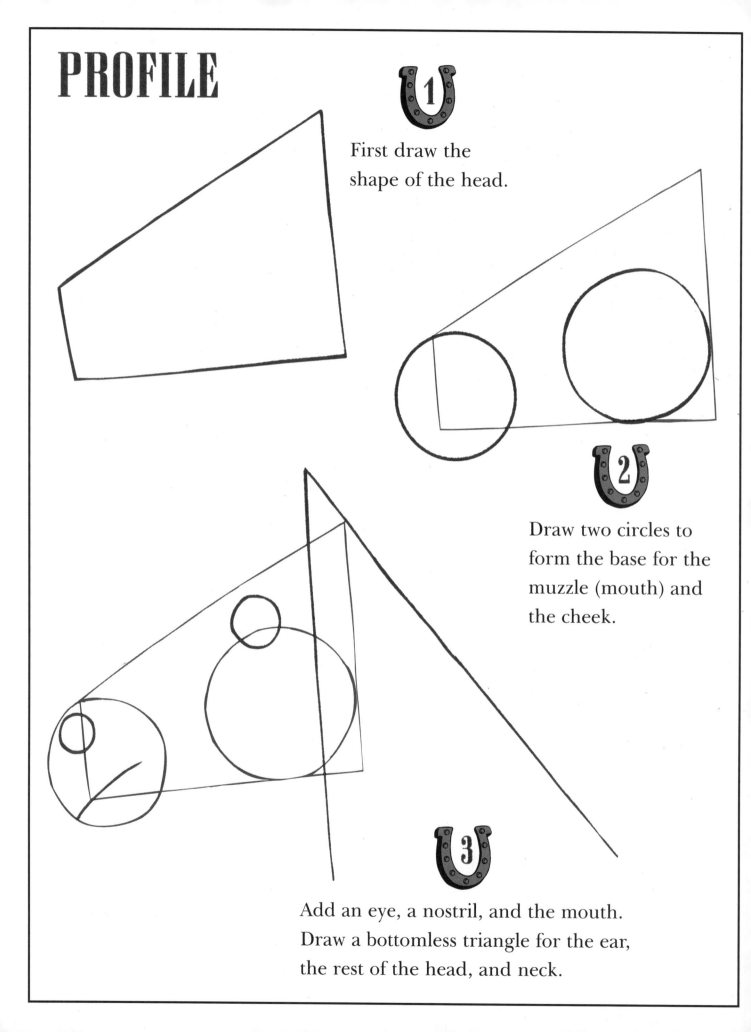

1
First draw the
shape of the head.

2
Draw two circles to
form the base for the
muzzle (mouth) and
the cheek.

3
Add an eye, a nostril, and the mouth.
Draw a bottomless triangle for the ear,
the rest of the head, and neck.

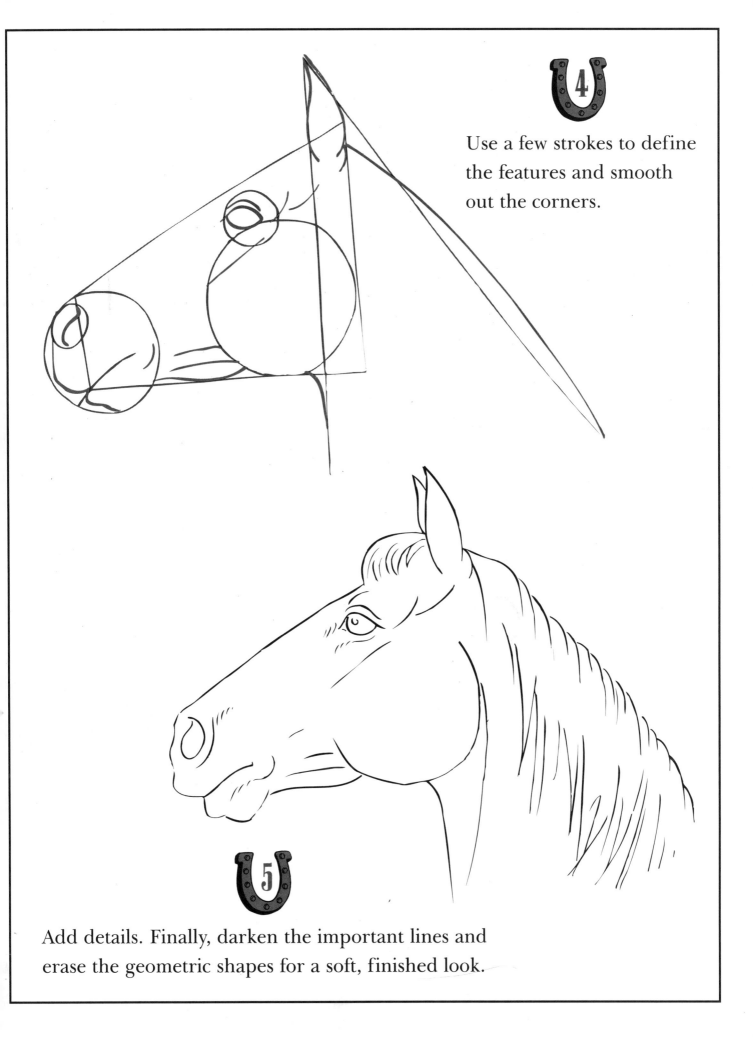

4 Use a few strokes to define the features and smooth out the corners.

5 Add details. Finally, darken the important lines and erase the geometric shapes for a soft, finished look.

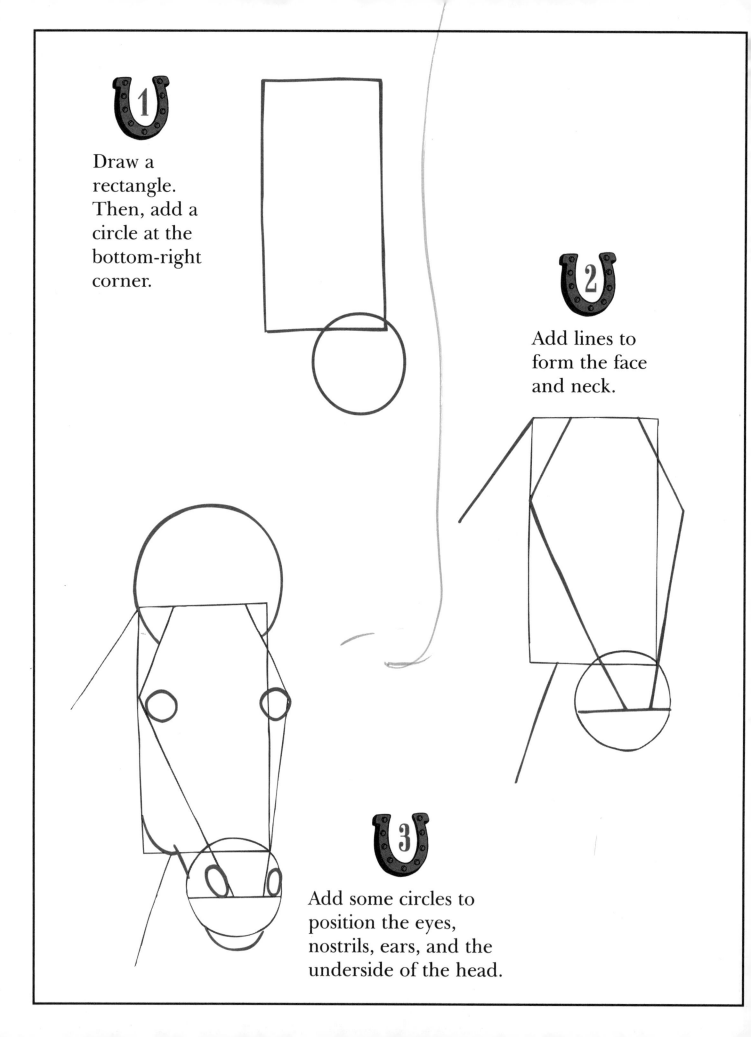

1 Draw a rectangle. Then, add a circle at the bottom-right corner.

2 Add lines to form the face and neck.

3 Add some circles to position the eyes, nostrils, ears, and the underside of the head.

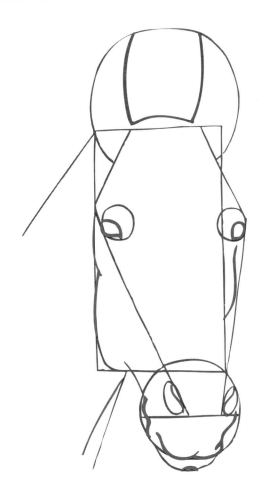

 4

Draw curves to outline ears, eyes, the edge of the face, and the neck.

 5

Add details. To finish up, erase the geometric shapes.

HEAD AT AN ANGLE

To begin the body, draw
two circles and connect
them with two lines. Draw
a triangle for the neck
and part of the head.

Draw circles about 1/2"
below the body to start
the upper legs. Then
connect the circles to
the body with curved
lines. Sketch the shape
of the head.

Draw in the bottom half of the legs
using circles and lines. Add a half
circle and a whole circle to form
the base for the muzzle and cheek.
Draw the top and bottom of the
horse's midsection.

SIDE VIEW OF BODY

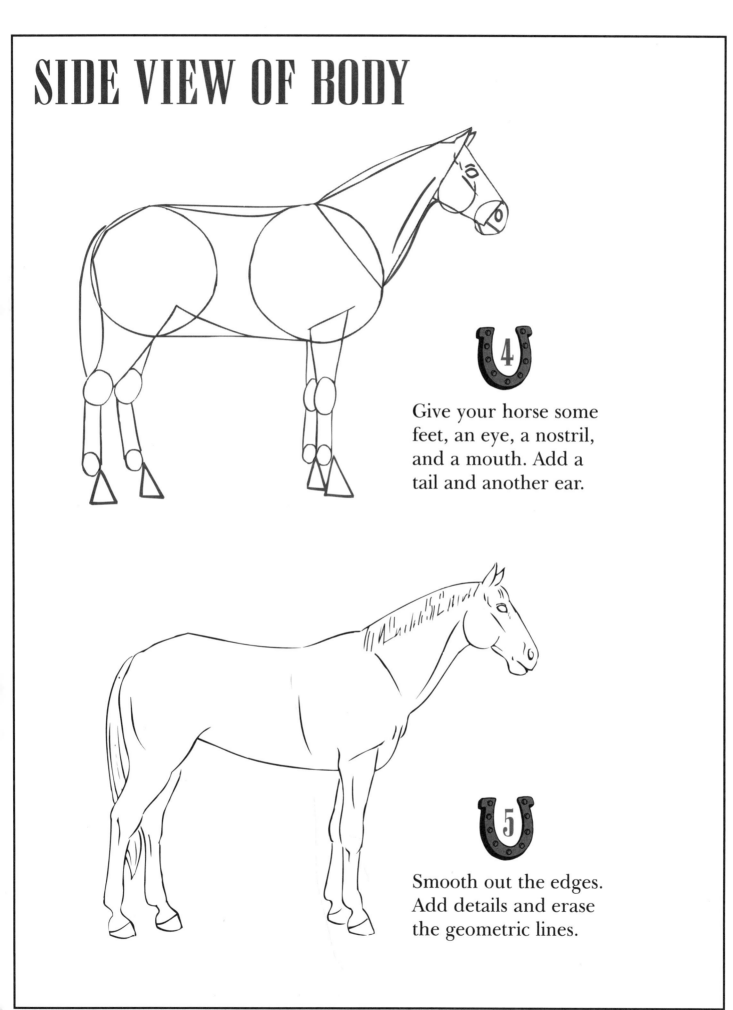

Give your horse some feet, an eye, a nostril, and a mouth. Add a tail and another ear.

Smooth out the edges. Add details and erase the geometric lines.

FRONT VIEW

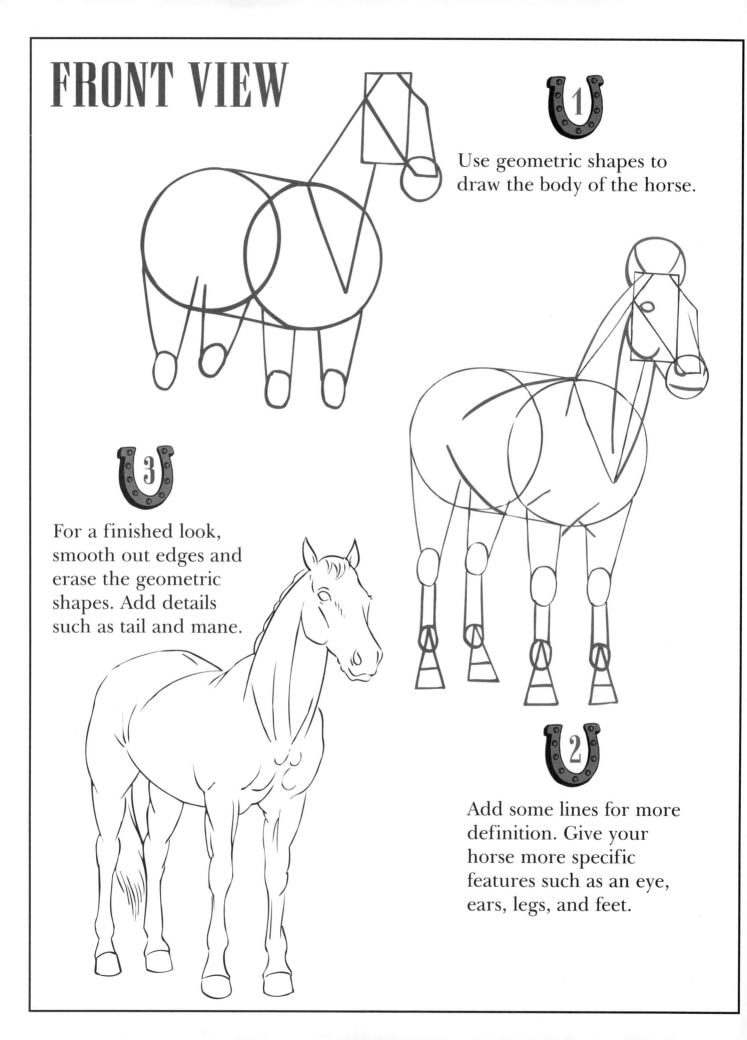

1 Use geometric shapes to draw the body of the horse.

3 For a finished look, smooth out edges and erase the geometric shapes. Add details such as tail and mane.

2 Add some lines for more definition. Give your horse more specific features such as an eye, ears, legs, and feet.

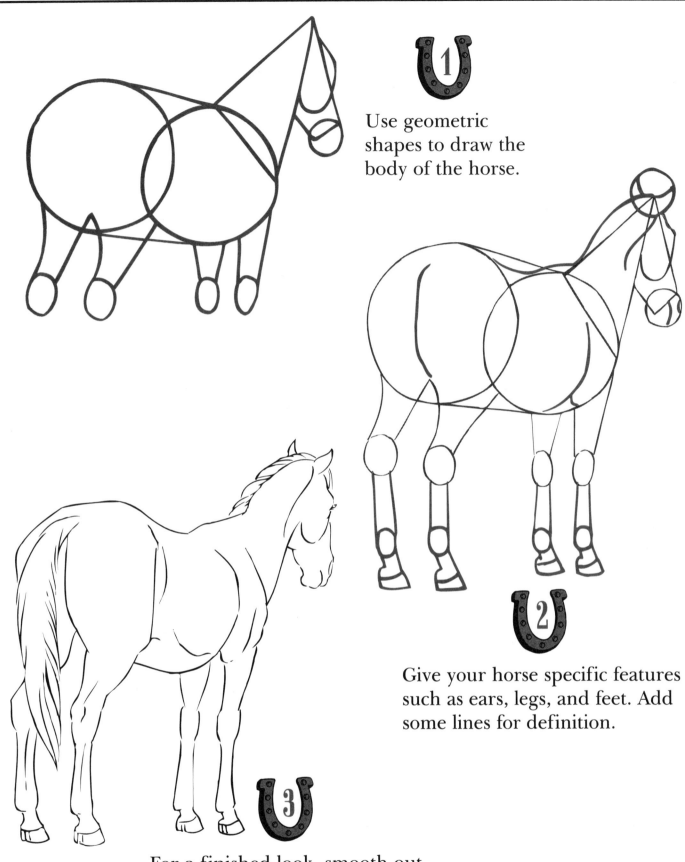

1 Use geometric shapes to draw the body of the horse.

2 Give your horse specific features such as ears, legs, and feet. Add some lines for definition.

3 For a finished look, smooth out edges and erase the geometric shapes. Add details such as tail and mane.

BACK VIEW

1

Draw two circles and connect them with two lines to form the shape of the body. Draw a triangle for the neck and part of the head.

2

Sketch the shapes for the head. Start the upper legs. Draw more circles and connect them with lines for the top of the legs. Put in lines for the back and stomach.

3

Give your horse lower legs, feet, an eye, a nostril, and a muzzle. Round off the neck and back.

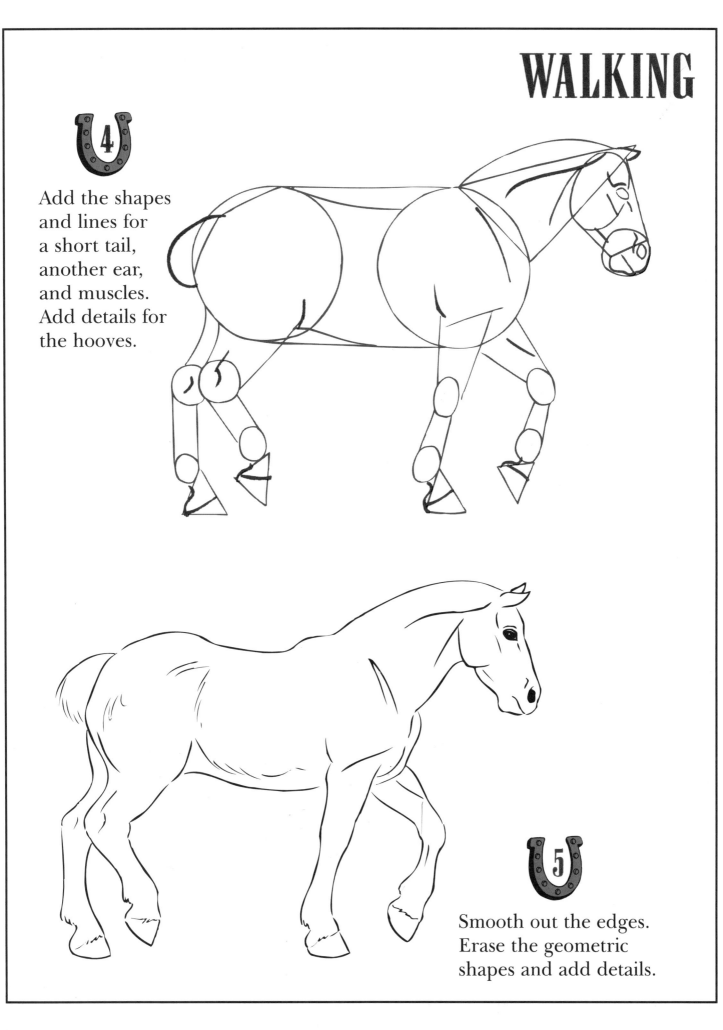

4 Add the shapes and lines for a short tail, another ear, and muscles. Add details for the hooves.

5 Smooth out the edges. Erase the geometric shapes and add details.

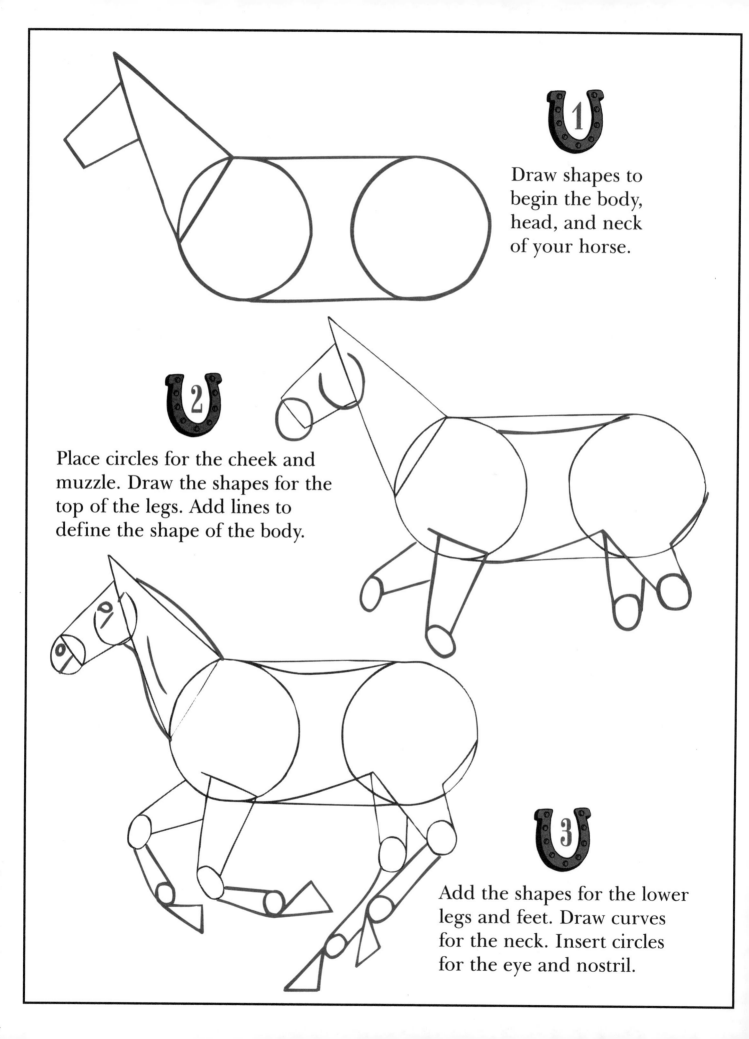

1

Draw shapes to begin the body, head, and neck of your horse.

2

Place circles for the cheek and muzzle. Draw the shapes for the top of the legs. Add lines to define the shape of the body.

3

Add the shapes for the lower legs and feet. Draw curves for the neck. Insert circles for the eye and nostril.

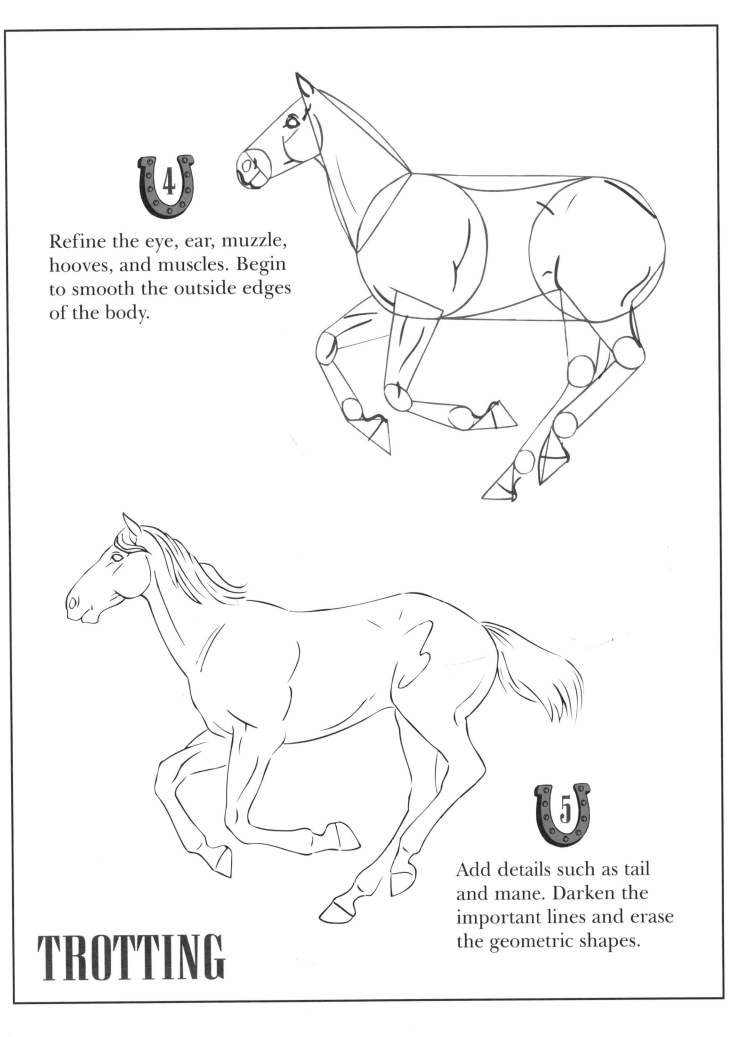

4 Refine the eye, ear, muzzle, hooves, and muscles. Begin to smooth the outside edges of the body.

5 Add details such as tail and mane. Darken the important lines and erase the geometric shapes.

TROTTING

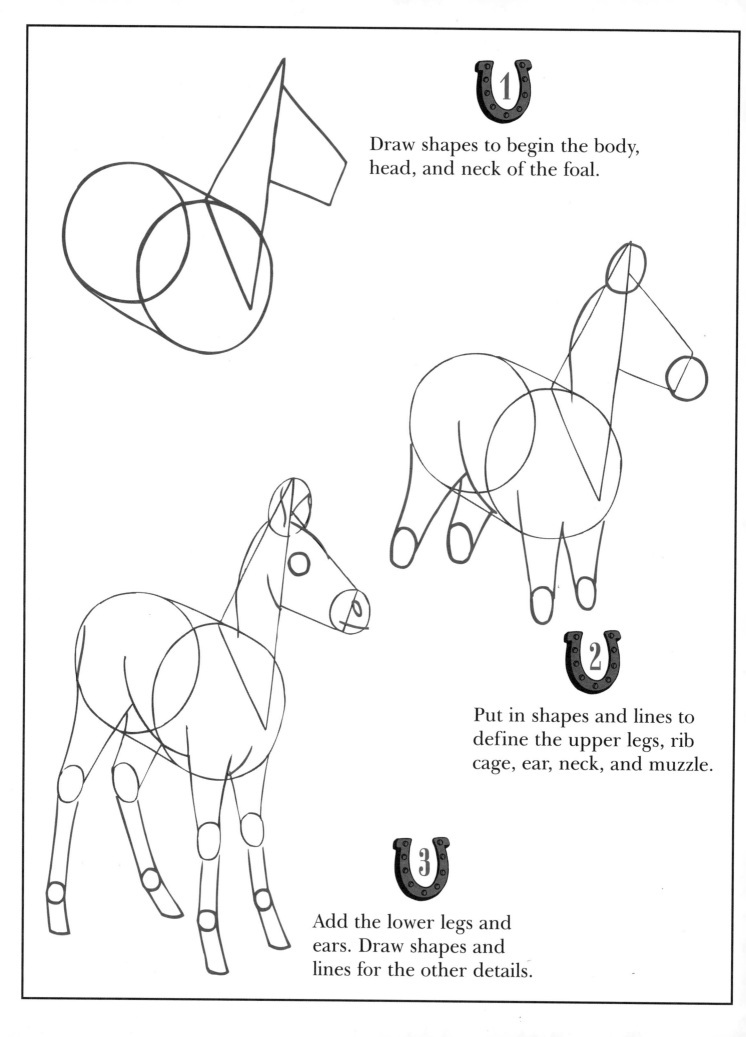

1

Draw shapes to begin the body, head, and neck of the foal.

2

Put in shapes and lines to define the upper legs, rib cage, ear, neck, and muzzle.

3

Add the lower legs and ears. Draw shapes and lines for the other details.

4

Add lines to define the muscles, tail, upper back, hooves, and eye.

5

Add details such as tail and mane. Darken the important lines and erase the geometric shapes.

FOAL

1

Begin by drawing the body and neck of the horse. Then, using the same shapes, begin the body of the jockey.

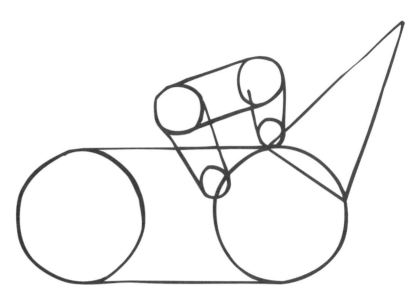

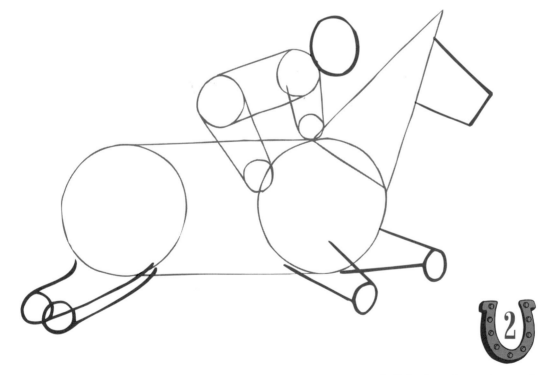

2

Add the heads to both figures. Then start to draw the legs of the horse.

STEEPLE CHASE

3

Give the jockey a cap, chin strap, and lower leg. Add shapes and lines for the lower legs, the face, and the mid-section of the horse.

4

Add shapes and lines for the jockey's facial features, foot, and hand. Add shapes and lines for the horse's facial features, hooves, and saddle. (Instructions continue on next page.)

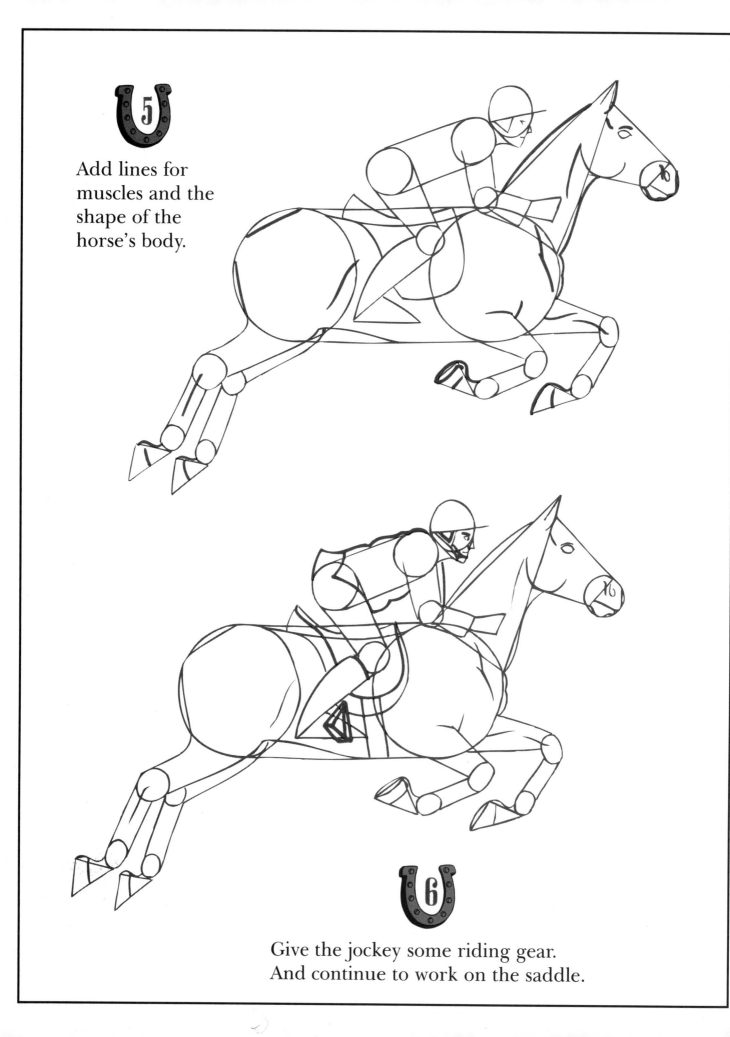

5 Add lines for muscles and the shape of the horse's body.

6 Give the jockey some riding gear. And continue to work on the saddle.

7

Draw a harness and a tail on the horse. Add details to the jockey's clothing.

8

Add more details. Darken the important lines. To finish up, erase the geometric shapes.

1

Start by drawing the shapes for the body and neck of the horse. Add a shape on top that will be the cowboy's torso.

2

Draw heads on the cowboy and the horse. Begin to draw their limbs.

3

Continue working on the limbs of the cowboy and the horse. Start the cowboy's hat. Add shapes to the horse's face.

 4

Add shapes for the foot and hands of the cowboy. Add shapes for the horse's facial features, feet, and ears.

 5

Outline the saddle on the horse. Also, add lines for muscles. (Instructions continue on next page.)

COWBOY

Put in details for the cowboy's face, hands, clothing, and saddle. Add the reins.

Draw the harness, stirrup, tail, and mane. Finish the saddle by adding the strap. Add more details to the cowboy's clothing and hands.

Add details, especially to the mane and tail. Darken the important lines and erase the geometric shapes. Draw a lasso in the cowboy's hand and add a shadow under the horse to give the appearance of jumping.

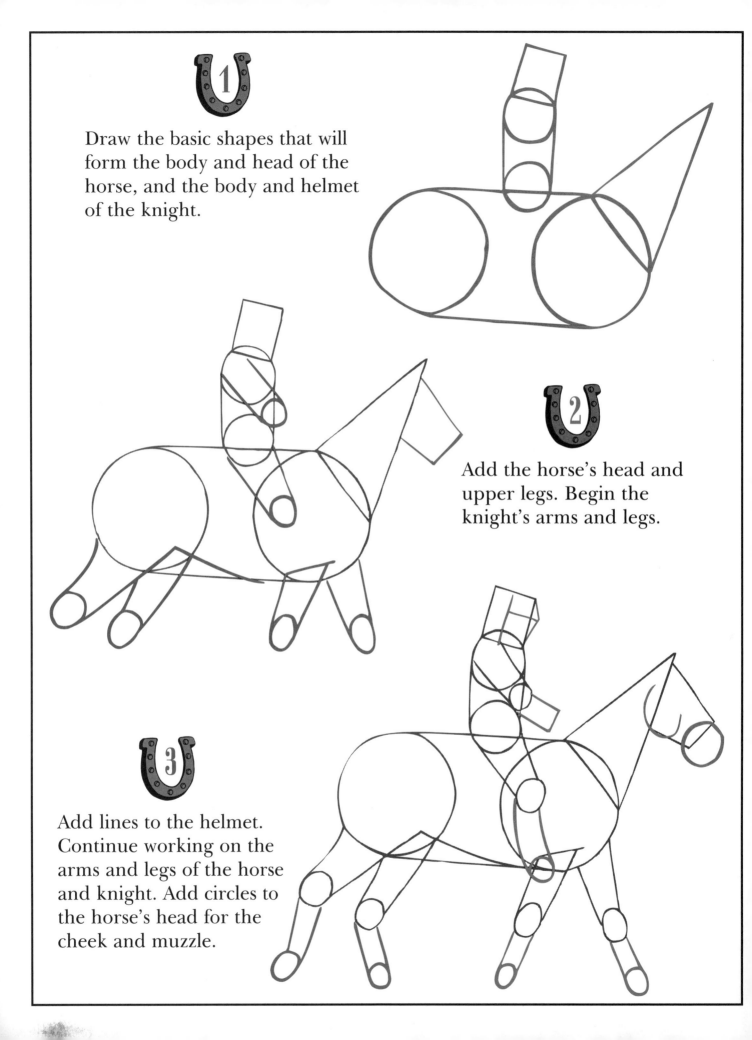

1

Draw the basic shapes that will form the body and head of the horse, and the body and helmet of the knight.

2

Add the horse's head and upper legs. Begin the knight's arms and legs.

3

Add lines to the helmet. Continue working on the arms and legs of the horse and knight. Add circles to the horse's head for the cheek and muzzle.

KNIGHT ON HORSEBACK

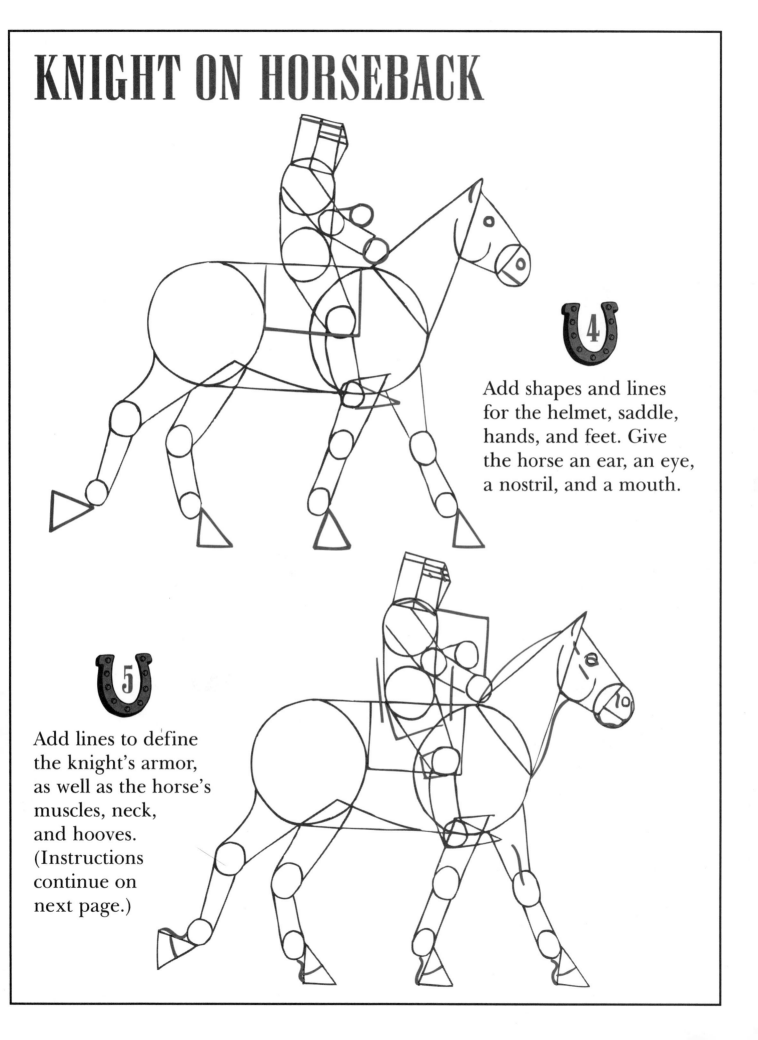

4

Add shapes and lines for the helmet, saddle, hands, and feet. Give the horse an ear, an eye, a nostril, and a mouth.

5

Add lines to define the knight's armor, as well as the horse's muscles, neck, and hooves. (Instructions continue on next page.)

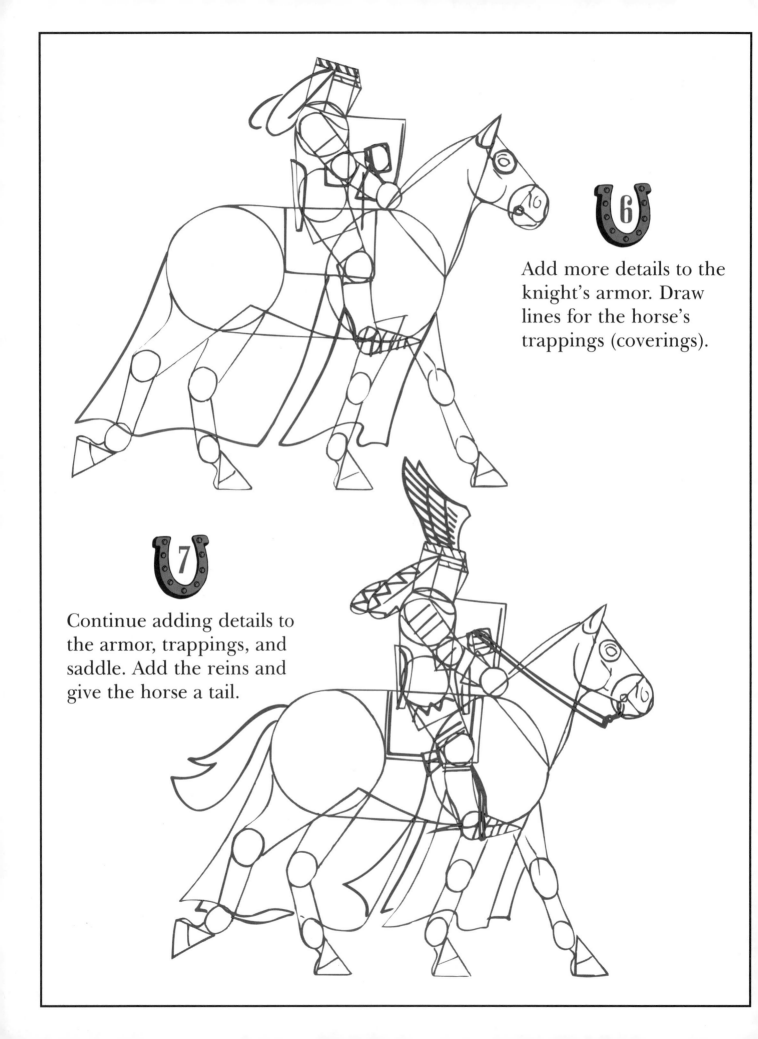

6 Add more details to the knight's armor. Draw lines for the horse's trappings (coverings).

7 Continue adding details to the armor, trappings, and saddle. Add the reins and give the horse a tail.

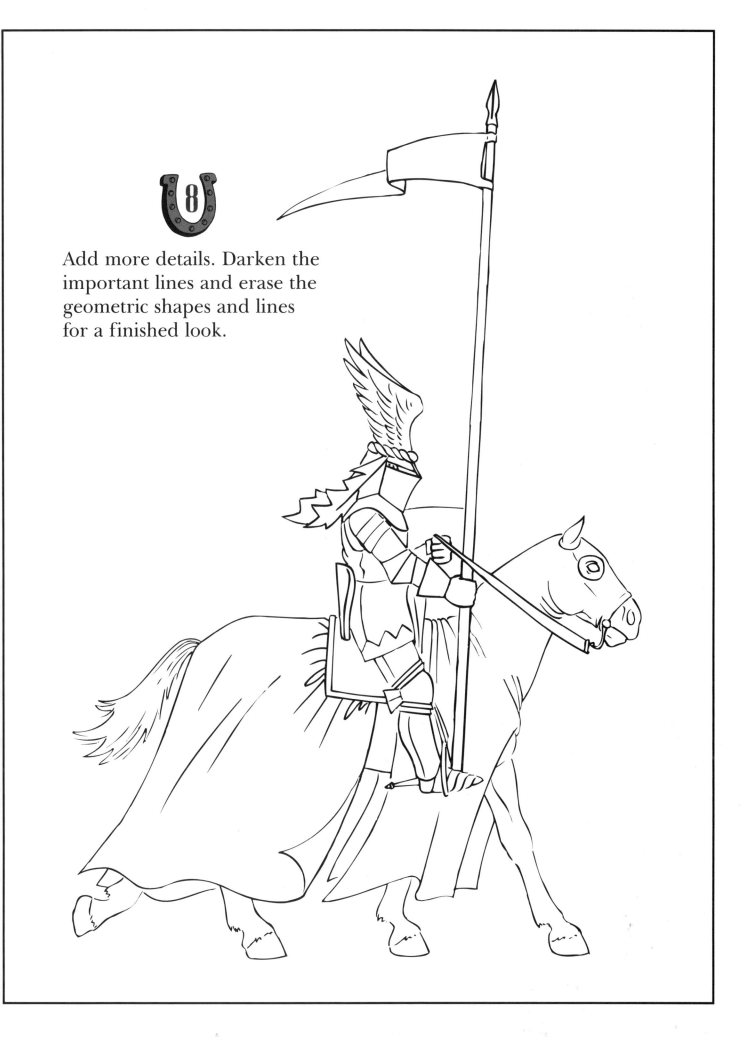

Add more details. Darken the important lines and erase the geometric shapes and lines for a finished look.

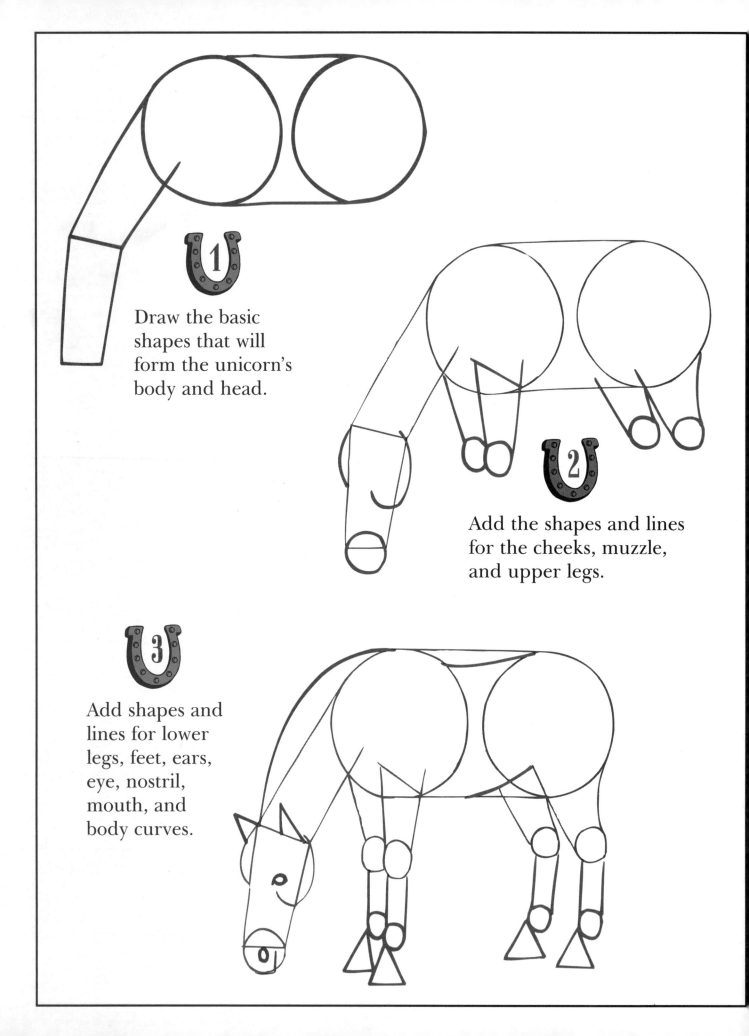

Draw the basic shapes that will form the unicorn's body and head.

Add the shapes and lines for the cheeks, muzzle, and upper legs.

Add shapes and lines for lower legs, feet, ears, eye, nostril, mouth, and body curves.

MY SKETCHBOOK OF
HORSES